Song of the Soul

Song of the Soul

POETRY OF LOVE, PASSION AND LIFE

ARUN MAJI

PARTRIDGE

A Penguin Random House Company

To order additional copies of this book, contact
Partridge India
000 800 10062 62
orders.india@partridgepublishing.com

www.partridgepublishing.com/india

Contents

Dedicated
to
all my beloved readers
and
to those who suffer
yet- they love, persevere and conquer.

Dedicated
to
all my beloved readers,
and
to those who suffer
yet they love, persevere and conquer.

About the Poet

Arun Maji's poetry is all about love, life and its sufferings. He believes- human suffering is braided with human existence and can't be avoided, yet- sufferings can be turned into a meaningful song with touch of love and passion.

His poetry is full of love, passion and emotion. While reading his poems- readers can feel those emotions penetrating their hearts. He is a master in evoking emotions among readers. He has thousands and thousands of readers over social network reading his poems.

His poems are spontaneous, simple yet have a great depth. He has deep understanding of love and life. His perception of love and life is based on Indian philosophy of love and life.

He explains- today's war, extremism and violence- all are result of lack of love, and love alone can solve these challenges. He is active in spreading message of love through his poetry and essays. He peacefully raises his voice against poor treatment of women, children and other marginalised people. He is involved in campaign to promote peace, harmony, tolerance amongst people.

He is a practising doctor in Australia.

About the Poet

Arun Maji's poetry is all about love, life and its sufferings. He believes, human suffering is bred with human existence and can't be evoided. Yet suffering can be turned into a meaningful song with which of love and passion.

His poetry is full of love, passion and emotion. While reading his poems, readers can feel those emotions generating their hearts. He is a master in evoking emotions among readers. He has thousands and thousands of readers over social network reading his poems.

His poems are spontaneous, simple yet have a great depth. He has deep understanding of love and life. His perception of love and life is based on Indian philosophy of love and life.

He explains - today's war, extremism and violence- all are a result of lack of love, and love alone can solve these challenges. He is active in spreading message of love through his poetry and essays. He peacefully raises his voice against poor treatment of women, children and other marginalised people. He is involved in campaign to promote peace, harmony, tolerance amongst people.

He is a practising doctor in Australia.

Acknowledgement

With utmost humiliation I express my gratitude to my mother and my late father. I owe every drop of my existence to them.

My sincere gratitude to my loving wife and my loving son. Without them, I could not live my life. I express my gratitude to my brothers, sisters and other family members; they have loved me always and unconditionally.

I owe my life to my teachers and my friends too, my sincere gratitude to them. There are people who have helped me without me being aware of; I bow my head to them. I am grateful to my friends on social network, who have encouraged me always and unconditionally. You all are angels to me.

My sincere gratitude to editorial team, designing team and production team of this book, they have worked hard to make this book one of their best.

I am grateful to all my readers for providing me valuable feedback and advice.

I am grateful to Amit Bhar for lending me his paintings for cover page and interior of this book. I am also grateful to Akash Ghosh and Sandip Samanta for lending their photographs for interior of this book.

Acknowledgement

With utmost humiliation I express my gratitude to my mother and my late father. I owe every drop of my existence to them.

My sincere gratitude to my loving wife and my loving son, without them I could not live my life. I express my gratitude to my brothers, sisters and other family members; they have loved me always and unconditionally.

I owe my life to my teachers and my friends too; my sincere gratitude to them. There are people who have helped me without me being aware of. I bow my head to them. I am grateful to my friends of social network who have encouraged me always and unconditionally. You all are angels to me.

My sincere gratitude to editorial team, designing team and production team of this book; they have worked hard to make this book one of their best.

I am grateful to all my readers for providing me valuable feedback and advice.

I am grateful to Amit Shah for lending me his paintings for cover page and interior of this book. I am also grateful to Akash Ghosh and Sanjoy Samanta for lending their photographs for interior of this book.

Preface

I didn't want to write poetry but I had to.

Life is whimsical- it has rainbows, it has darkness. Those rainbows and darkness then play together, laugh together, fight together and even cry together; and all these happen within ourselves. Then a time comes when our war-torn souls have a very compelling story to tell. That story is so compelling that we can't hold it within us any-more.

Because that story is whisper and tears of soul; and music and dance of heart- it becomes a song, the song of the soul.

I didn't realise, I had a song to sing until a dark night came; when that night over-powered me. I remembered my old days as a little boy when I saw only exquisite beauty in this world. Then- I kept walking along the streets of life; and I saw- the pain, the sufferings, the hatred, the betrayal, by the streets of life. Without my conscious knowledge, those happenings by the streets hardened me. And I became a *new me with my soul dying*.

Realising that- my heart was heavy, eyes were shinning with tears; through tears I could see that forgotten little boy was smiling at me with sorrow in his eyes. It was then I whispered few words- "I wanna be that child again" and those words turned out to be my song.

I realised I got many unsung songs within me, and those songs need expression. Hence I started writing poem. "Song Of The Soul" is that song which was imprisoned in me for years.

I don't know why my soul whispers so much of love! My soul forces me to believe that if I love more and more, I will heal my wound within me. Since I never can eliminate sufferings

from my life, healing of my wound is the only option left to me. Often I argue with my soul on this, but in the end my soul wins.

"Song Of The Soul" is song of love, passion, life and its sufferings. Since, my soul is the part of the soul of this universe; I guess my song won't be much different to song of others. I am confident, many will identify with this song.

Having said that, there would be something in this book, some may not agree. That is quite normal. Since we all are different, we may see same thing from different angles. But at the end- we all are thirsty for love. And "Song Of The Soul" speaks of love.

I hope, you all love it.

Big hug to you all.

SECTION I

Love and Passion

God And Love

O God
you offered me two choices.

One was -
to be your *follower*
and walk your path;
and another was-
to be *me*
and follow my own path.

I tried both
and found them merge together
to a common path called *love*.

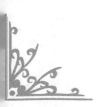

Butterfly

I love butterflies
because they are,
like you,
soft as velvet,
coloured like a rainbow,
sensitive as a new-born' skin.
It's not butterflies
that I want to talk about!
It's you.
Talking about Butterflies
is just a waste of time,
Although useful,
to draw attention
to the beauty you both share.

Relishing Love

You are like soft butter
on warm soul of mine.
You melt easily into my soul
making me sweet and slippery.
Then I relish myself-
my lips, my heart, my soul
all is so sweet and slippery!

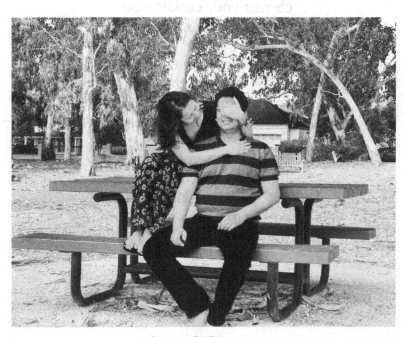

Photo: S Samanta

Savouring Love

I like you-
raw as- fresh cut apple
green as- young olive leaf
spicy as- red hot chilli
juicy as- dripping ice-cube.

I would jump into you-
caress you, cuddle you
savour you, squander you.
As if-
I am a little child
and you are an ice cream parlour
As if- I am an angry bull
and you are a beautiful rose-garden.

I would eat you up all.
I would spill, I would dribble
I would faint, I would collapse-
only to wake up again, even emptier-
and ready to savour you again.

Beauty Of A Mystery

If you ask me-
What is it, I love in a flower most?
My answer is- kind of a "I don't know"!
I love that "I don't know" in a flower.
I love that captivating mystery;
Seeking beauty there is my paradise.

If you ask me-
What is it, I love in your eyes most?
My answer is, kind of a "I don't know"!
I love that "I don't know" in your eyes.
I sink into your eyes and get lost there;
Seeking myself there is my paradise!

Gift Of Love

When your eyes shine
my dream re- lives.
When your face smiles
my hope re-breathes.
When your lips kiss
my wound repairs.

You transform mundane life
to a joyful existence.
You transcend time and space
to exist in every existence.

To be lost into you
is to find myself anew.

Glory Of Love

For- I have tasted your honey
I don't want to live, or die any-more;
I just want to float, swim and sink
in your ever flowing sweetness.
I want- weary time to stop flowing
and mourning space to stop crying.
Let them watch- how I melt into you
and make wind- sing the song of a river.
Let them watch- how I get lost into you
yet- reappear as moon in night sky.

Photo: S Samanta

Your Cherry Lips

I love cherry
not because they are-
red as blood
or juicy as a peach
or sweet as sugar;
but because they are your lips.

If I find a cherry
my day is done.
First, I feel it
then I tongue it
and then- I bite it;
as the juice flows
I suck it to my heart.

Then- my heart goes dizzy;
and it beats faster than vibrating light.
I huff and puff, I choke, I gasp
and then- I faint;
when I wake up, I suck it again.

It's not cherry that I suck-
it's your juicy, succulent lips.
Cherry is just a cue to your deliciousness-
it reminds me of- your sweetness,
your juiciness, your lasciviousness.

My love, don't ever kiss a rose
it might suck you dry-
and leave me intensely thirsty.

Estranged From Soul

How far is your one sweet kiss?
I smell your fragrance, touch your softness
feel your wetness, taste your sweetness;
but that's all in a dream, a fleeting dream.
Then dream goes- leaving me in emptiness!

What an wait to drink your honey!
I mistake- rain for your bell
wind for your song, moon for your smile-
my this fervour comes with a heart-break;
for- I see you, yet I can't hold you
I hear you, yet I can't embrace you.

Aeons ago, we met each other-
once- you were moon, I was sky
once- you were river, I was sea;
we always united to *one*.

You and me- we were born as one
You the soul, me the body- we were one.
Then we split, you travelled to sky
and me waiting for you on this earth.
My soul-less existence weeps now.

O beloved, please be kind to me
be with me always, not just for a while;
fill my heart with your sweetness
and light my life with your sparkling smile.

Beauty Of Love

As sun changes from dawn to dusk
so does your beauty.
Sometime- you are a river
dance me a dance of a star.
Sometime- you are a flute
sing me a song of my heart.
Sometime- you are cloud
you kindly quench my thirst.

In your smile, I see sun-rays and river
in your lips, I see cherry and flower
in your eyes, I see ocean and water
You are formless, in your fleeting forms-
you perfectly wrap- my formless love.

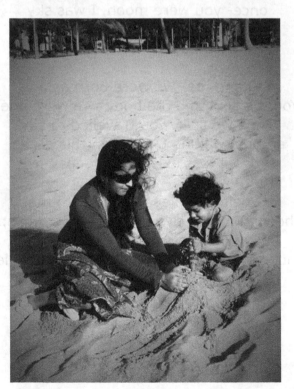

I Miss You

Alone in a corner-
I feel like- listening to music
and cheer me up.
So I play with albums–
all genres- rock, pop, soulful;
yet- nothing satisfies my soul.

I wish- if I could hear you now,
whispering- soft in my ear!

I Like the Way You Are

I like the way you are.
Moon might beat your smile
yet- you smile best.

Moon can't smile
with a broken heart;
she can't sing
with a broken flute.

But you-
a mortal being of mortal world;
you- fall, break, cry and despair
yet- you dare to live, smile and sing.
You smile through agonising pain!
Your smile has a life of its own-
it beats, it flows, it sings
and in darkness, it cries too.

I like the way you are-
don't try be the sun or the moon;
be yourself. Your own self.
I feel home with your weakness;
you don't have to abandon them.

Let Me See Her Face Again

Wait, o beautiful End
let me see her face again.
I want to continue living
just to be with her.
I want to be born again
just to be with her.
O cruel End- why can't I stop
and see her face again?

Let my memory of love
pervade the heaven.
Let my tears of sorrow
melt the heart of heaven.
Let my pain spare none
in this abode of heaven.
Let my soul's love
make them cry in pain.

Wait, o beautiful End
let me see her face again.

Love and Living

So what- if the house is small?
We have vast sky to live under.
So what- if the food is not lavish?
We have joy in sharing together.

While birds in my eyes chase you
would you fly- in sky of my mind.
While beats of my heart play music
would you sing- in my soul's mind.

If- rainbow writes a song
on canvass of happy, wet sky;
would you whisper that song
while, I hear, cheer and fly....

As wind- you pervade me
and remove pain of my soul.
As river- you flow through me
and wash, all griefs of my soul.

Photo: Akash Gosh

Your Happy Hips

I love your hips-
for the way, they sway
making my heart cheer
and dance your rhythm.

I love them
not because they are-
heavy as a mountain
or round as earth;
but I love them, for-
they are *you*.
They are-
bubbly as your heart
and soft as your soul.

Watching you walk
I forget myself; I forget-
who I am, where I am.
I just watch smile and dance
of your happy hips.
I feel like- I explore them
to find source of your joy!
Even in my sleep, I dream-
my heart dances
rhythm of your hips
while my soul plays the song.

Love Doesn't Fade

In cracks of my lips
hide those kisses of your lips.
In wrinkles of my chest
hide those wounds of your nails.
In deafness of my ears
hide those songs of your heart.
In blindness of my eyes
hides that smile of your eyes.
In scars of my heart
hides that love of your soul.

You fade into horizon
I fade into senility
yet- our love sustains.

Love Found Within

My cry for you echoes in wall of silence
and gets back to me again and again.
Then I search you- within me.
Aha! You are already there caring for me.

Love's Despair

Though I want to sing my heart
yet- nobody wants to hear me.
Though I want to dance my soul
yet- nobody wants to watch me.

Does she sing the same song
as my heart sings so painfully?
Does she dance the same rhythm
as my soul dances so sorrowfully?

I dream my dream in her eyes
hoping to build a nest by the river.
I sing my song in her rhythm
hoping to tell her, that I love her.

I give her all- my dream, my eyes
yet- she does not understand me.
I wait and wait, for her to return
yet- she never ever returns to me.

Magic Of Love

With just one kiss of mine
I can tell you how this Universe was born.
With just one touch of mine
I can break the great wall of your resistance.
With just one probe of mine
I can measure very depth of your great-sea.
With just one beat of my heart
I can sing the song of your beautiful soul.

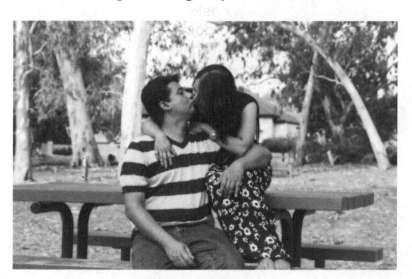

Photo: S Samanta

Memory Of Love

I ask Time-
"where have you taken my beloved to"?
Time says-
"to the land of memory;
it's a beautiful place-
no wall, no ticket.
visit her there, any time you like
stay there, as long as you like."
I ask-
"How is she doing there"?
Time replies-
"as good as she did here".

My Borrowed Existence

Tonight, I can paint smile of moon
it's easy- for I have seen you smiling.
Tonight, I can sing song of sparrow
it's easy- for I have heard you singing.
Tonight, I can dance rhythm of river
it's easy- for I have seen you walking.

I've nothing of my own, nothing!
As if- my everything comes from you-
my song, my dance, my dream- everything.

My Song

Didn't you hear my song
that I sang to wind, long ago?
That was whisper of my heart
dream of my eyes, dance of my soul.

That song was written-
with borrowed- cry of flute,
tears of river, story of moon!
That song meant to carry- me,
my ache, my smile, my dream
all to your soul.

If you heard it
tell me- if you could love me!
Wasn't that song enough-
for you- to love me?

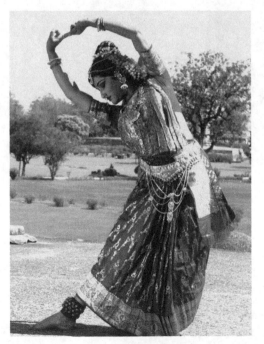

Rise To Love

You're that secret darkness
which holds dazzling light.

Blind I go, drunk I go
I know not- why I go, where I go
yet- I *do* go.
I go towards that secret darkness
which holds dazzling light.

Love is a journey-
from darkness
through darkness
to a secret darkness;
that holds dazzling light.

Only I can see, the fire on your lips
only I can taste, the honey of your fruits
only I can feel, the flood of your river;
I, all alone, in secret of your darkness.

While passing through darkness
my outer shell is torn and abandoned;
and the light within me enlightens my path.
My "self" is forgotten, my desire is forgotten.
In garden of flowers, who remembers pain of thorns?

Your Honey

I am happy
on your breasts.
They are-
warm as spring
soft as rose-petals
nourishing as sea.

I wonder-
why sky and moon
are so happy and healthy!
They must have
drunk- your honey.

To Love Is To Be The Smartest

I love the way, you kiss a rose.
I love the way- you hold her
cuddle her and kiss her.

I wonder- if love is that simple!
What's in you that you can-
make love look that simple?

If I hold you- it looks so clumsy
if I cuddle you- it looks so weird
if I kiss you- it looks so strange!

Show me- how to hold you
and dance rhythm of your heart.
Show me- how to kiss you
and shiver with your trembling lips.
Show me- how to cuddle you
and melt myself into your warmth.

Or, I can just plunge into your soul
and do nothing but melt within you.
Yet- your dance will still be my dance!

Praising Love

I see ocean in your eyes,
sun on your face, moon in your smile.
I feel- lotus on your golden skin
and sweet cherry on your rosy-lips.
If I see you- I see this universe unfolding
if I feel you-I feel this eternity blossoming.

Tell me-what else can I do
but lose myself again and again in you?

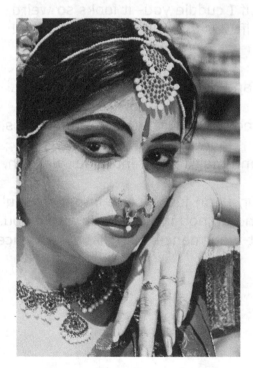

Your Memory Makes Me Go Wild

I fear your memory-
it's so wildly wild!
Every smile of yours, is wild
every whisper of yours, is wild
every dream of yours, is wild!
Your memory tickles my soul-
it makes me gasp, tremble in ecstasy;
my skin burns, my mouth dries
my heart pounds, my soul cries;
as if- I must drink you then, and there
to keep me civil and sober.
Poor me! I can't keep my dark secret
in secret enclosure of my soul!

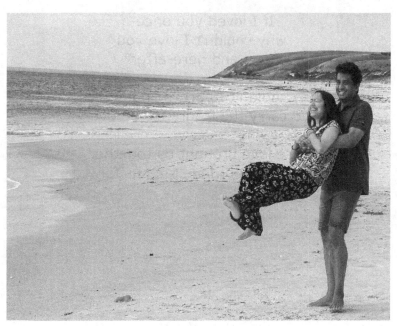

Photo: S Samanta

Parting

Let our parting be-
sweeter than our union;
let our forgetting be-
soother than our memory.

One day-
cloud parts from the sky
and soul parts from the body.

Why the moment of parting
would be full of sorrow or anguish?
Why the road of parting
would be flooded with blood or tears?

If I loved you once-
why couldn't I love you
now; and here-after?

Why couldn't I part, being in love
and carry the fragrance of love?

Once love brought us together
now- let our love take us far.

Love Kills Ego

As I drown- in **sea** of your love
I gasp- and swallow more of your love.
Swollen with love, my "I' sinks and dies.

My soul is free and happy now-
he floats- on sea of your love;
with no worry of drowning.

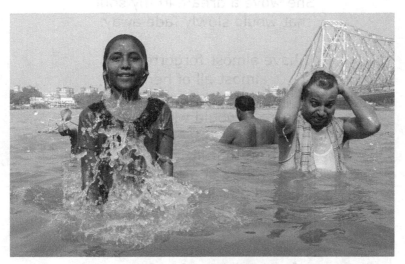

Photo: Akash Gosh

Pain Of Memory

Oh my heart!
Why can't you forget her?
Is her love so indelible-
that you can't forget her?

She drew a rose on my lips.
Time would wipe that away.
She wove a dream in my soul
that would slowly fade away.

I have almost forgotten her,
almost all of her.
Just a little pain, just a little laugh -
I am sure, I would win them over.

Yet, that little kiss
becomes a sea of delight,
and that little dream
reaches celestial height.

Oh heart
see if you still have her fragrance?
Her sweetness on my lips
has almost gone.
Its loss helps my penitence.

Haste my heart, haste
before her love becomes all consuming.
I deny her again and again
and yet, she returns gracefully singing.

Twin Soul

Though my intense thirst
wants to drink you all at once;
yet, my soul wants
to cherish you, only little at a time.
My soul wants to devour you
in this life, after-life, and for eternity.

I will drink you a little, then pause-
for river, to swell you up a bit more
for wind, to enliven you up a bit more
for sun to brighten you up a bit more.

River, wind and sun- they all are
in service of our love;
for they are children of our union.

Aeons ago, you and me united as cloud;
then- your sweet honey flowed as river
your gasping breath blew as wind
and your bright smile sparkled as Sun.

Couldn't remember, who loved first;
for- you and me were born in union.
In between your soul and the shadow
I was woven as your dancing heart.

Verse Of Tears

I smell your fragrance in wind
so- I follow wind, to a river.
There, your fragrance dies-
making my heart stop.

I hear your song in cloud
so- I follow cloud, to horizon
there, your song fades-
making my soul cry.

In ocean, I see your face
in wind, I smell your aroma
in river, I watch your dance
in whisper, I hear your music.
If I stretch my hands to embrace you
I end up embracing emptiness.

My tears ache and write a verse-
how it would- win your heart.

You Are My Serenity

Being alone is a bliss to me;
not because- I like the serenity,
rather- it's the wilderness in solitude
that thrills me, intrigues me.
If I'm with you alone- I'm doing it.
If I'm with me alone- I'm rehearsing it.

"Dirtiness" is a dirty word to me;
I like those kinky, nasty thought of yours.
I like the way-your greedy tongue
plays on my intensely thirsty lips.
I like the way- you bite me, eat me
and make me bleed.
I like the way- you run your nails
teasing me, hurting me, wounding me.
I like the way- you tremble, shiver
and convulse, bouts after bouts.
I like the way- you groan, moan, cry
speak filthy words and gasp breathing.
I like they way- you calm down at last
after screaming like a thunder.

Tell me- what is so dirty about it?
Isn't this- my way of telling you
that- you are my serenity?

Why Love Fades

Years ago, I could-
see you in sky
smell you in wind
and feel you in flowers.

Then our love faded-
its eyes went blind
I could hardly see you now;
its nose got blocked
I could hardly smell you now;
its fingers went numb
I could hardly feel you now.

I wonder-
why my love fades
but moon's love does not?

Would You Stay in My Heart

Would you stay in my heart
like the beat of my heart.
Would you sing in my soul
like the song of the spring.

Would you awake in my heart
like bright moon in the night.
Would you dance in my soul
like a stream from the height.

The pain of your memory
would sing song of our love.
The bliss of your laughter
would dance rhythm of our love.

That song in your whisper
would renew love on this earth.
That dance in your laughter
would revive fervour and mirth.

I Won't Hold You Back

I won't hold you back;
I would make you fly-
high above the sky.

When you are in-
sun, moon and stars
I would be there;
either wiping your tears
or sharing your laughter.

Let me be-
wind under your wings-
helping you fly high.
Let me be shade above you-
saving you from storm.
Let me be star ahead you-
guiding your dream.

Let my love free you-
to the infinity that you are,
to the love that you are.

Being a mortal mind-
it might hurt me to part from you
yet- the joy of seeing you fly
would heal, all my wound.

Tell me- what's more divine
than seeing my love plays
with sun, moon and stars?

You Are My Destiny

I wait for you-
as a rose waits for a bee.

Many bees come, and sing her a song
many bees come, and dance her a music
yet- none of them fills her heart;
except that- "sweet little bee".

We all have a destiny-
heaven or hell- we all have a destiny;
nothing fills our heart but that destiny!

You are my destiny-
if I end up in you- that's my heaven
if I die awaiting you- that too my heaven.

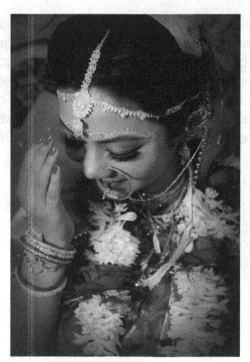

Photo: Akash Gosh

Window Of Your Soul

It's more exciting to play with your hair;
than play with words and write a silly poem.
For-bend of your hair is slippery and intriguing-
I chase them like a cat but lose them soon.
I can spend my whole life, even an eternity-
just by playing with your slippery hair.

They feel good, they smell good-
While playing with them; I even enter your soul-
through the pores of your hair; like a drunk, dipping oil.
Once inside- I can turn myself to those chemicals
between flowers of your soul; and act as transmitting signal.
With every dance of your flowers- I go from cold to hot,
green to red, purple to blue. It's real fun out there!

But the real fun is- when you sleep;
I can wake you up, as your wild dream.
I can be decent, naughty, kinky or anything;
of course- as per command of your heart!
Being inside you, I learnt your likes and dislikes!
Now I am tuned to your soul- I am mostly red;
since- every time you like it red and hot.

Heaven Is Where The Love Is

As soon as sun sets-
we land up in dream of moon.
We cuddle each other
and moon feels the tickle.
We sing to each other
and moon hears the music.
We make love
and moon moans in ecstasy.

Peeping Tom Moon
peeps through window;
when mortality makes love
heaven shudders in pleasure.
Moon knows- the word "ecstasy"
has a carnal smell in its mortal flesh.
Moon envies me-
in its after-life, it wants to be me.

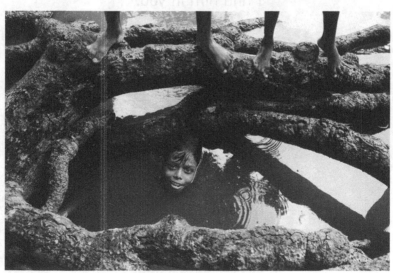

Photo: Akash Gosh

Why I Love Your Lips

I love your lips.
They are-
soft as butter
sweet as honey
scented as rose
inviting as wine
and hot as fire.

But- those are not
the reasons- I love your lips.
I love your lips-
because they are your lips.
They share- your soul
your blood, your heart.

My soul-
doesn't live with me;
I find him in you.
That way-
your lips are my lips;
I love them too much.

Doorway To Your Soul

If I read a poem-
then- all of a sudden,
all unknown to myself-
those letters become you;
few become your song
few become your smile.
I can- see you, hear you
cuddle you, embrace you.

We-
talk a lot, laugh a lot
sometime- we even fight.
We fight over, why-
moon is so sombre,
sky is so restless,
and wind is so insane!

I am destined to you;
no matter- where I am,
what I am;
my love finds you easily.
Rain reminds me your song
wind reminds me your whisper
river reminds me your dance!

As if- everything that exists
is a doorway- to your soul.
When I feel them, I feel you.
when I love them, I love you.

Gone With The Wind

That floating cloud came
and then went away.
That flock of birds came
and then flew away.
But- where are you?

When- your bell rings in my ear,
your laughter echoes in my heart,
your fragrance floats in the wind-
Then- my eyes shine, face brightens
and hope flies high.
But- when I look for you
in trail of the wind, you're not there.

My hope sinks, as sun sinks in horizon
my heart aches, as day disappears in night.

With wind you come
with wind you go away.

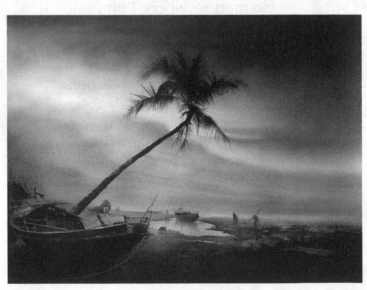

Painting: Amit Bhar

Don't Ask Me

You ask me- to love you.
Tell me- how do I do it
when this is already done?
How can I undo my love
and love you again?

I loved you long ago-
When I was the sun
and you were the river.
I awoke you in dawn-
and we played day long.
Then in dusk- I hid
behind your heart.

Don't ask me- to do
that is already done.

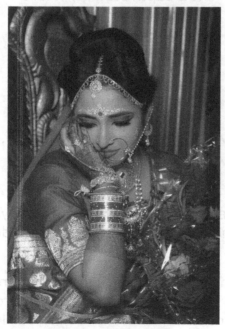

Photo: Akash Gosh

Desire

Why did you love me
and uncover my secret wound?
If you loved me, then why-
you left me drowned in sea of desire?

I was kind of ok, so were you;
absorbed in comfort of routine life.
We enjoyed- dawn in comfort of bed
and dusk drowned in work.

My soul then didn't know what was
love or music
Then I saw a rose, a rose
not as a cue of love's smile.
Then one evening- by the lake,
you blew breeze of love.
You captivated my heart
you soothed my soul.
You awakened me
to a world of madness.

Now- I am that straw
waiting to be burnt to ashes.
Now- I am that dead river
waiting to be overflown to sky.
Ignite fire
on my parched heart;
let me burn-
let my flame go high in the sky,
and dance like a drunken tornado.

My lips shiver in thirst,
my body shudders in excitement
my soul cries- begging your mercy.
I want to be burnt- in fire of your love;
burn me, burn me to ashes.

If I Die

If I die- I want to be your lipstick, after-life.
I would stick to your lips- all day long
and saviour your succulent lips.

If I die- I want to be your eye-liner, after-life.
I would keep staring at your depth-
and pain you, if you ignore me

If I die- I want to be thread of your bra, after-life.
I would sleep on your flowery softness
and cuddle your flowers in my dream.

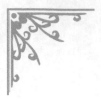

Sticky Love

How I say, what it feels like-
to see you, hear you
and think about you?

Swallow does not care-
what or how he tells about spring;
he just keeps singing and singing
about his birth, in womb of spring.
I too keep- thinking, dreaming
and singing about my birth
in womb of your love.

For me, what matters most is-
floating on the ocean of your love.
I don't care if I do a butterfly
or a breast-stroke or a free style!

Though secretly, I like freestyle most-
I would do, whatever my soul wants.
I don't care if they are my dark desire.

I may roll on your love
or I may crawl on your love
or I may even spin on your love.
For me, what matters most is-
stay tethered to each atom of yours.

Don't ever let me
untwine myself from you.

Make Your Honey Sweeter

What is wrong if I am crazy
to drink your sweetness?

Sun is crazy, waits for dusk
to drink all honey of the sea.
Moon is insane, waits for night
to drink all wine of the wind.
Thirsty they are, they get hungry
hungry they are, they get thirsty!
What's in life of a humming bee
but drinking rose's sweet honey?

Let my lips dissolve into yours.
Let me stay there; If I die ever-
make your sweetness sweeter.
Death would be such a wonder
If only, your honey is sweeter!

Longing for Beloved

No matter, how much I sing
my sorrow would never end.
No matter how much I love
my pain would never end.

In dream- you live, as bright
as first day, when we had met.
In heart you sing, as louder
as first day, when we had met.

Alas! Today you are so far-
you're behind that night-sky.
Every-time, I try reach you
I tear heart, falling from high.

It's long that you are gone
yet, my thirsty heart desires you.
You have faded in the horizon
yet, my soul wants to paint you.

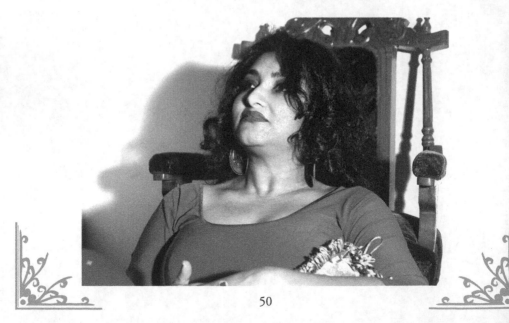

Wet Beauty

You're wet, very wet-
your flowers see through your wetness
your fruits peep through your wetness.

Rose wants to kiss your lips
Sun wants to cuddle your cheeks
sky wants to see through your eyes
Moon wants to smile through your face.

What's in your wetness, that-
my eyes crawl on your skin
my lips crave for your honey
my hands tickle for your softness
my heart aches for your soul?

I wonder, if rain wets you, or you wet rain-
as a dew-drop sparkles on glory of grass
so- a rain-drop sparkles on glory of yours.
While you're wet, you wet everything
me, my soul, my passion everything.

Tea Garden

I smell green tea
on your orange skin.

Your skin is an unknown garden;
with beauty, fragrance and sweetness
but without a sign describing, what it is!
In my child like curiosity, I feel it, rub it
squeeze it, smell it, taste it; to find what it is!

More I explore your garden, crazier I go;
in my drunken wilderness, I feel like-
plundering your beautiful garden
and drink all tea, at once.

Then my soul wakes up
it tells me-"what an idiot you are!
If you can get a sea-size ecstasy
by drinking just a single drop of tea-
why would you plunder whole garden?"
You know- it makes a lot of sense!

Since it's your flowery bosom
that I like most, I would lie down there
and drink one drop at a time.
I would be drunk, then go to sleep
and on waking up, I would drink you again.
Don't ever drive me out of there
let me stay in your garden forever.

I Am Wild

My patience is as much as–
the distance between your lips and my lips!
My restrain is as much as–
the distance between your bosom and my breasts!
My discipline is as much as–
the distance between your shadow and my soul!
Since those distances *never* exist
so is my patience and discipline!

I'm wild, very wild–
as wild as this wind and sea;
each moment, I feel like–
I plunge into you!

Why won't I?
If sky stares at you every moment
if wind touches you every moment
then– why won't I?

Fruits Of Your Garden

I love your fruits!
Not because, they are-
soft as pulp, yummy as honey
or juicy as watermelon
but because- they are *yours*;
they are fruits in *your* garden.

Though I am hungry, I don't care food.
I can just look at your overhung fruits
and satisfy my unquenchable thirst.
Mere look at them, ignites a fire in me
I feel dizzy, I feel drunk, I feel frenzied
I land up in moon with your fruits in my hand.
I feel them, I scratch them, I poke them
as if- I am a child in the garden of God
who knows not, what to do with heavenly apple!
So-I just get lost, in mystery of your fruits.

Don't drive me out, if I put them
into my mouth and go for a dream!
If they are inside me, I feel- my heart is full
and soul is content with pride that I own this universe.
Let me remind you- no way they are
less than- this infinite universe.

If I slide to abyss, of treachery or lie
I can just hang on to your fruits
and save me from humiliating fall.
That way- they're my rock, my lifeline.

My Rose

I love rose
not because- it's pretty or soft
or it has fragrance that arouses me;
but because- it's you!

Its red petals remind me of your lips
its sparkle reminds me of your smile
its fragrance reminds me of your nectar.

If I find a rose, I hold it to my chest
tenderly, very tenderly. And I feel-
your bosom touching my breasts,
as I tremble- I hold you firmer and firmer.
I close my eyes and I can smell you.
I get drunk, I get mad. In my wilderness-
I kiss it and I can feel your juicy lips-
that softness, that invitation, that fragrance!

Ask that rose- how much I missed you last night!
It would tell you- it is pounded and tormented
with my cuddle, care, kiss and secret pain.
It would tell you- how dry it feels now
for I have drunk all its honey!

Ocean Exploration

Let me do, what I do best.
Let me hold you and look at you-
all day long, all lifelong.
Let me lose myself into your dreamy eyes
and try find dream, that I haven't dreamed yet.
Let me remember your radiating smile
for I have never smiled like you yet.
Let me stroke you, your forehead, cheeks
ears, chin; and let me play with your juicy lips.
Let me plant kisses; not just one, may be four
may be hundreds, may be many, many more.
Let me run my finger, and play a guitar
as if your hair is the strings of that guitar.
Let me see you again- one end to the other;
for my insatiable soul will never be happier.
Please keep quiet, and let me see you again
I need to focus, I want to lose myself again.
Let me feel soft valley between your hills
Let me wander on your beautiful buttery hills.
Let me see what is on top of the hill- I mean the crest
let me stroke that again and again, I do this very best.
Wow! It hardens when I stroke, what a magic!
Are you blushing? Do you like this magic?
Let my fingers dance on your glorious stage
let them dance ballet or flamenco on your stage.
Let me check- what is hiding in your beautiful bay
maybe- not today; I have too much to do, today.
Let me hide your bay for a day or two
hide it carefully; so that nothing, even I can do.
I will sink in your ocean on another day-
and dig all those gold's, jewels, nectar on that day.
Oh, it's so hard not to sink in your ocean today
maybe- I do now; may be- I should wait for another day.
Then let me do- what I have done so far, again
let me feel you, fondle you again and again.

Stroke Of A Brush

Sit by the window.

Let setting sun-
glow your face in golden red.
Let silver shine of light-
shine your flowery smile.
Let shadow of windows-
deepen your sea-deep eyes.
Let my thirsty soul-
crave hungry soul of yours.

Let the time be frozen
let earth stop her spin
let wind stop her song
let Sun stand still.

Sit quiet;
let me paint you now-
let me paint- sea in you
sky in you, rainbow in you.

Let strokes of my brush
stir every atom of yours.
Let dream of my brush
colour every mood of yours.
Let my thirsty brush
kiss your inviting lips.
Let my weary brush
shade your eyes in shadow.
Let laughter of my brush
brighten your soul.

Sit quiet, we are not done yet.
Let my brush crawl up your thigh

Let him hear you moan, groan and sigh
Let him hear you cry in pain
Let him hear you cry in pleasure.
Let him go on and on- don't stop him yet.

Let him go little higher-
Let him dance a song there.
First- a slow ballet
then a fast rhythm of flamenco.
Let him dance
while you sing loud.

Now-
Let my brush sink into your ocean.
Let him sink deeper, and deeper
Let him explore your honey and nectar.

That was-just the first touch
let him finish the fine touch now!

SECTION II

Life's Philosophy

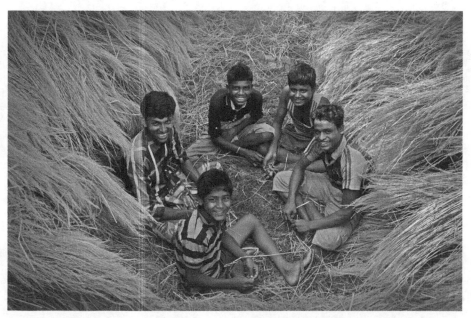

Photo: Akash Gosh

Art, Heart and Soul

There is no poem
it's only whisper of heart.
There is no music
it's only song of heart.
There is no dance
it's only rhythm of heart.
There is no painting
it's only dream of heart.
There is no art
it's only soul's dialogue
to this beautiful universe.

Who I am?
I'm the union of a couple
called "heart and soul"
and art is my expression!

Murder Of A Soul

Long ago
there was a little angel in me-
who would see the sky and touch the sky
who would see the fire and catch the fire
who would see the flower and kiss the flower.
He would smile, laugh, jump and cry.
He had clear eyes, he would always find-
exquisite beauty and elegance in this universe.
He would just smile and smile
as if- life was a garden of rose-
and he was there to devour it.

As he grew, his vision betrayed him.
His eyes went hazy with greed, jealousy
hatred, anger, cruelty and conspiracy.
He no longer could see world as beautiful.

Now-
he sees fire in sunrise
and hell in moonlight.
That little boy is dead now!

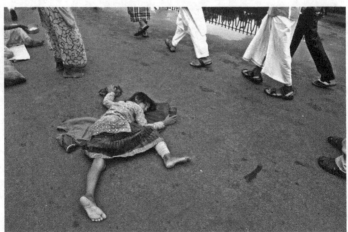

Photo: Akash Gosh

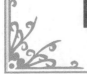

Finding My Story

O heart, listen to
whisper of the wind;
for- wind carries the story
of your beloved, far away!

O soul, smell-
the fragrance of flower;
for- flower carries the aroma
of your love, made aeons ago!

O eyes, see-
the dance of river;
for- river carries the rhythm
of music, played at your birth.

I have no tale to tell;
all stories are already there-
in soul of sky, sea and sun.
If I listen to them, I find myself.

Big Bang Theory

I loved you aeons ago!
Then, you were a star
and me, a cloud of gas.
Gravity of your infinite love
hurled me to your bosom.
In union, we spun and spun
until you made a loud shriek;
your that shriek of ecstasy
created this infinite universe.

Creativity Of Insanity

World is less of a pain
when we're drunk and insane.

Insane moon keeps smiling
drunk, deluded sun keeps burning.
They don't care
the contempt of a clever!
Insanity makes them do
what they do.

What they do?
That child hopes to smile
like that insane moon.
That spent soul resolves to burn himself
like that deluded sun.

Isn't this insanity's laughter
that holds universe together?

O mighty God
make us all insane.
I pity this clever world.

Dependence

Waiting and waiting-
for- moon to smile better
and sun to shine brighter.
Yet, I've never thought of-
rubbing my eyes clearer
or walking to them closer.

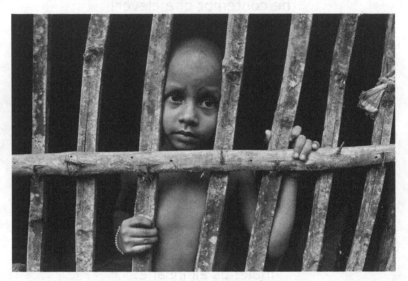

Photo: Akash Gosh

Gift of Silence

Silence of night is my paradise.
It's then- I whisper to my soul
and listen to music of my heart.
It's then- I connect to the sky
and devour dance of the river.

Silence of night is that canvas
where- I paint my soul
in colours of my imagination.
That's when- I am me
that's when- I am my best.

Illusion Of Immortality

Immortality is for dead;
for me, humility of dust.
When kind- I am beautiful
when loving- I am smart.

I am life, not a framed-
beauty on wall either.
I am far more beautiful
in embrace of my lover.

Forgiveness shines my eyes
and gives me sun's dazzling;
compassion sweetens my soul
and gives me rose's sparkling.

In life, why would I paint
fanciful dream of death?
Immortality is the illusion
that stifles life's breath.

If I walk looking high up
I fall in trench of a hell.
Neither song, nor dance
would await me, if I yell.

Infinite Soul

I am here
and everywhere.

I blow with wind
carrying fragrance of flowers.
I flow with river
carrying dream of dead oysters.
I fly with time
carrying blood of my ancestors.
How can my infinite soul
be contained within time and space?

If you imprison me
I will break, and hide behind sky.
If you grasp me
I will slip through, and then fly.
If you kill me
I will have rebirth, and then live by.
Tell me- how can an infinity
be contained within our fragile sense?

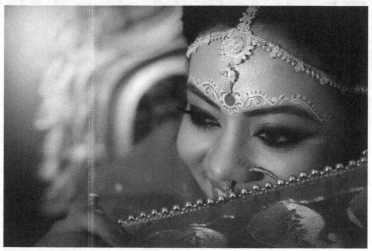

Photo: Akash Gosh

Arun Maji

My Ambition

I don't want to be a big man!
I just want to be a little band of rubber;
if someone bleeds- I would hold his wound tight
and save his one single drop!

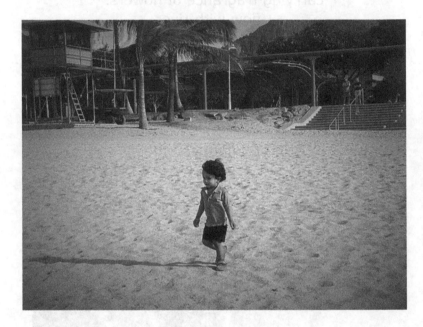

My Broken Teeth

Finally my teeth broke.
They had to;
I used teeth for reason
I was not supposed to.

I bit hearts, I bit souls
I tore flesh-of others.
Then I flaunted my bloody teeth
to this pathetic world;
yet, none protested.

But finally, time did it;
it broke my teeth.

One Soul

That was just another night, then-
moon was small, and night was faint.
Then you laughed-
your face glowed and teeth sparkled;
through your eyes, appeared
the beauty, of this elegant universe.
Moon got bigger in pride
night got brighter on your shine
wind could not help but play music!
And me? Not knowing what to do
I just kept looking at you.
I wondered-
how could an infinite galaxy live
In your tiny, little dark eyes?
As I kept looking at you-
I could see the Jupiter, the Mars
everything spinning and dancing
around your glowing soul.
May be- I should have been there;
maybe- I was already there
dancing with Jupiter and Mars.
May be- your lips were my lips
maybe- your breath was my wind
maybe- your shine was my soul.
How could you turn my soul
into yours, and yours to mine?

Let's Do Nothing

Let's do nothing-
for- we have done enough;
yet – it brought us nothing.

We have won war
yet- we could not bring peace;
we have worshipped God
yet- we could not bring virtue;
we have conquered star
yet- we could not bring light.

Let's pause, let's do nothing;
let silence pervade our souls
and make us silent and serene;
let's not- speak, hear or see-
let's just be still and silent
and hide in abyss of time.

Let's not be anything
for we have been too things-
big, colourful, famous- too many things;
yet- we wished we were nothing!

What an irony of 'doing' or 'being'!
We do, only to be eager to undo it;
we be, only to be eager not to be it;
let's not even pray or dream anything-
for a moment at least, tiny moment;
let's see- if nothing could bring us something.

We were born to be human
but ended up being a monkey;
we are-jumping from branches to branches,
making lots of grimaces and shrieks.
Yet- when the sun hides beneath the sea
we find, our act is so meaningless-
branches broken, leaves fallen;
day gone, heart tired and soul dead.

Let's pause, let's do nothing.

Patience

I walted and waited
yet- it didn't rain.
Frustrated, I cooked all seeds
and made them a meal.
As I was eating my meal
I heard rain dancing on my roof.

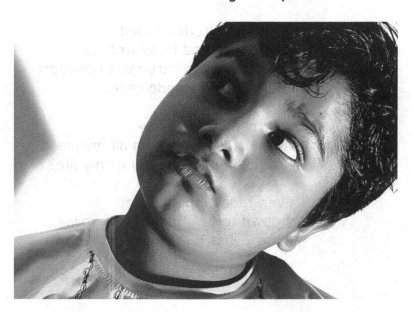

Tell Me- What Has Changed

Tell me-what has changed?

As a little baby
I clung to my mother's breasts
waiting for her- to cuddle me to comfort
and feed me to fullness.

Now, I am in death bed
my heart aches and body writhes
I wait for my daughter- to care me to comfort
and love me to condolence.

Why didn't I know-
it was love that I kept seeking all my life
it was love that I kept receiving all my life?

Even today, spent night
waits for dawn to brighten her sorrow.
Tell me- what has changed?

The Child in Me

I love children, not because-
I am kinder than anybody else;
but because- they make me
see- "my long lost me" again.

If I see a child
I become a child.
As if, I have-
his little steps on earth
his flowery smile of moon
his fervour of wild wind
his curiosity of new-born river
his serenity of a still lake.

World is a beautiful world
in child's beautiful eyes-
life is pleasing, sun is smiling
and dawn is so fascinating!
As if- every moment is a bliss
and worth living for.

There's nothing big
about a big man-
heart is small, smile is measured
and step is so cautious;
as if- his life is imprisoned.

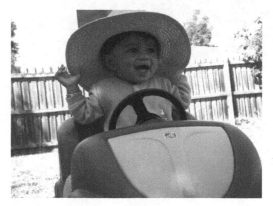

The Great Surrender

When utterly lost within you,
I am so happy-
I don't want to find myself any-more!
How come my giving in
be the brightest of the victory?
I don't have to think any-more
I don't have to worry any-more-
I just have to float and float
on current of your sea.
It's quite intriguing-
I float, then flip, then swim
and then float again.
Gosh, what a current you have!
It's- fascinating as lightening
smooth as rose
maddening as wine!
Why didn't I know before-
that my chosen surrender
is the greatest of the victory?

The Unexplainable Me

You think I'm a cool girl?

Well, I am cool,
as cool as the moon.
If only life had such serenity.
Even I don't know who I am.

I could be as crazy as a loon.
I could be as funny as a clown
or as twisted as a corkscrew.
I'm unexplainable.

I am- as unexplainable as life and death,
as unexplainable as the pyramids
It's you, who makes me what I am
If you see a river in me, then you must be the sea.
If you see the moon in me, then you must be the sun.
If you see fire in me, then you must be the volcano.

I may seem like everybody else,
yet I am unique
and though I am of this universe –
I am really... just a woman.

Truth

I thought truth is a dung-
it can't move of its own;
and when pushed-
it upsets people
it angers people.

Then I found-
truth is indeed a butterfly.
It can- fly of its own
with its coloured wings;
and ignite imagination
in deaf, dumb and dead.

Waste Of Life

Between life and death
there we are; for -
as short as blink of an eternity.
While we argue
on inevitable life and death-
our song dies starving.

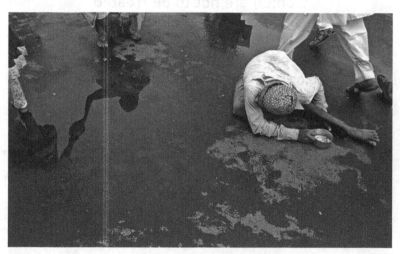

Photo: Akash Gosh

Women Are Flowers

Women are *not* like flowers
Because they *are the flowers*!
They are- where the creation hides
they are- where the beauty hides.
Women are not to be respected
because- they are to be worshipped.
Women are not to be treated
because- they are to be glorified.

We can- see them, praise them
glorify them and worship them;
and fill our heart with eternal joy!

We Are Dusts

I met death, last night.
He kindly said-
"I just knocked your door
to see how you were doing."
I said-
"please, keep knocking my door
you keep me so humble."

We Are Thirsty For Love

What is so divine about love?

Pale moon brightens up-
listening to music of your love.
Sad river resumes dancing-
watching the dance of your love.
Thirsty eagle gives up thirst-
feeling the pain of your love.

O Sun
why do you ache?
I would beg moon
to love you more.

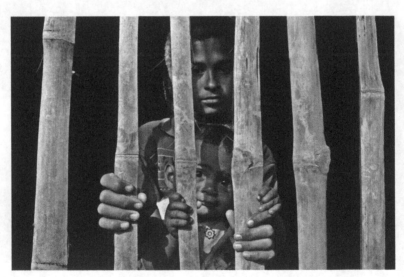

Photo: Akash Gosh

When It's Time To Return To Star

In dusk of life
everything is quiet;
quiet is the wind
quiet is the sea.

When heat dissipates-
vapour cools down to water
and life cools down to soul-search.

That song echoes in sky-
"It's time to return to star";
wind whispers that song
river mutters that song.

Before that final journey-
a little bit of preparation
a little rehearsal of dialogue.

Let me- light the lamp within me
and open the window of my soul!
Let me rehearse-
"O beautiful Death
sorry, I got bit late!
In midst of life
I almost forgot you.
Tears in my eyes?
Oh, that's nothing-
I've never seen heaven
so, I loved this earthen world;
maybe I loved it too much.
Honey, why are you crying?

I am going bit ahead
follow me when you can;
but don't hurry!
I have asked florist-
for me, he would bring you
a rose every day.
Now- kiss me a good bye".

No Judgement Is Ever Right

Sky ends
where my vision ends;
dream ends
where my imagination ends;
causality ends
where my intelligence ends.

How can I paint portrait of the Sun
when I can see only shadow of the sun?
How can I sing song of your heart
when I can't hear whisper of your heart?

Don't ask me- measure depth of your eyes,
that depth surpasses extent of this universe;
then how my blurry-vision ever measures it?

Let me just love you-
let me measure you, only with my love.
For my love alone, can see your eyes
listen to your heart and follow your dream.
For my love alone, can see through darkness
move faster than light, swell more than a sea.

How Beautiful You Are

Don't wear flowers.

Come naked;
naked as this sky, sea and the soul.
Beauty is the sky-
it will colour you in hue of serenity.
Beauty is the sun-
it will colour you in dawn of hope.
Beauty is the moon-
it will colour you in smile of love.
Beauty is the sea-
it will colour you in sparkle of soul.

Undo your wear
and let me see through you;
if you have sky, sea and moon in you!

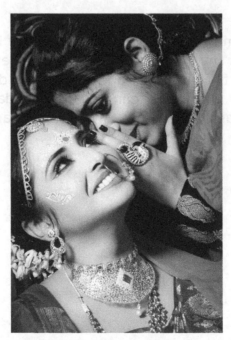

Photo: Akash Gosh

Be A Child Again

If you want to be happy, content
then, swim against the current-
don't grow old
be a child again.
Life is a conspiracy-
it degenerates you to insanity
by robbing you off your ingenuity.
Tell me- what is more dreadful
than living, life of a soul-less corpse?

I Like You Naked

I like you uncovered-
as bare as sky, as naked as moon;
don't you wear flowers
you are beautiful as you are, always.

Bareness is truthfulness
bare is the soul, bare is the sea.
If anything not yours, it's not yours-
why would you borrow shadow of Sun
to make you look like a Sun?

Decency is cooked in greed and blood;
in decency lies the politics of morality.
those who hides there, are evil of humanity.

You are the truth-
bare as sky, naked as moon.
Don't you wear flowers;
you are beautiful, as you are
now and forever.
Please undress, I like you naked.

Hope and Pain

Once our roads crossed
and we walked together for a while.

Habit of togetherness
then divided us again.

Alone, by the sea-
I see a boat appears in horizon
my eyes smile- "it's you"!

That boat then fades again
and my heart stops.

SECTION III

Life and Its Sufferings

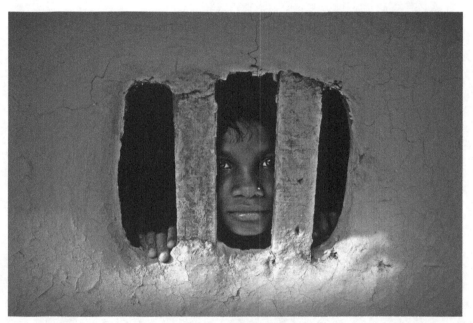

Photo: Akash Gosh

If I Were A Child

If I were a child-
I would play "hide and seek" with the sun setting
and play "peek-a-boo" with the moon rising.

if I were a child-
I would dance with the river
and play with the grasshopper.

if I were a child-
I would sing to that bird in the tree
and fly with the wind in hurry.

If I were a child-
I would win the sky for my mother
and bring her all joy and laughter.

If I were a child-
I would paint a rainbow on earth
and bring my friends, all glee and mirth.

If I were a child-
I would float like a cloud
and make my grandma very proud.

If I were a child-
I would just play and play
yet, never worry if my hair turns grey.

If I were a child-
I would just love and love
then- make everyone pet a dove.

Goodbye My Mother

Don't cry mom, don't cry.
Dress me up- as you do for my school;
give me your those three kisses-
one on forehead, for good luck
another on lips, for I am sweet
last one on cheek, for I am naughty.
Then- wave me goodbye
and keep waving, until I fade in horizon.

Don't cry mom, don't cry;
nothing is more painful
than your achy, writhing tears.
Your tears drench my heart
and choke its rhythm.
Your pale face dries my soul
and stifles my throat.

Grandpa says-
star we come from, star we return to
I will return to star, mom;
It's pretty sad though, that I go earlier
but I will await you there, forever.

I have overheard doctors
they say- my time is ticking.
So, dress me up- as you do for my school;
give me your those three kisses-
one on forehead, for good luck
another on lips, for I am sweet
last one on cheek, for I am naughty.
Then- wave me good bye;
and keep waving, until I fade in horizon.

How To Part

If you want to part, then part.
But before you part, don't stand apart.

Hold thy breast onto my bosom
if that pleases my heart.
Paint thy love onto my lips
if that sweetens my memory.
Smile bright for one last time
if that comforts my soul.

Let our parting be the beginning
of a new love- far from selfish desire.
Let our parting be the uniting force
that would bring us even closer.

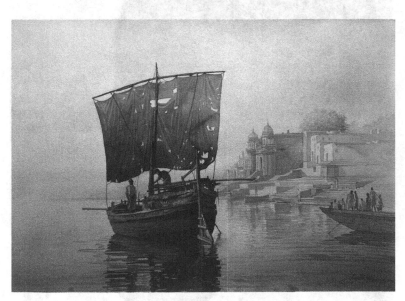

Painting: Amit Bhar

I will be A Child Again

I didn't want to cry
yet- I was crying.

Night was silent
and moon was penitent.
Through film of tears-
I could see a little boy-
smiling with the stars.
He was inviting me
to play with him.

I must-
I miss myself so much.

Life Of A Superstar

Once I loved-
flashes of cameras laughing together,
while I smile and sway my hips on red-carpet.
Click-click sound and glittering light;
they all absorbed me, and thrilled my heart.

Then I didn't know-
flashes had burn, it burnt my soul
carpet had blood, it wounded my heart.

When I was a star, above earth
I didn't feel the pain of a lowly dust.
Now, life has thrown me to earth,
it has to;
things those have gone up, have to come down.

I never knew what it felt like
to be a earthly dust!
Now a dust, I am kind to dust.

Love and Pain

You loved me a little
but hurt me a little more.

Your love now evolved into a star
and your hurt evolved into a crater;
though sometime, star shines that crater
yet, mostly it's very dark out there!

Why did we hurt each other
when we indeed, loved each other?
Why did I love you, yet- hurt you?
If hurt is so braided with love
then- why hurt hurts so much?

Why can't I let you go-
your love, your kiss, your hurt
everything, everything together?
Why do I carry them forever?

How easy they are-
to forget and forgive?
How easy it is- just to love
but not be hurt?

Isn't love a rose with thorns?

What Hurts Us More

I am like everybody!
I also cry and shed my tears;
I also wish- someone, sometime
would cry with me and wipe my tears.
I also feel numb and dying;
I wish someone then- would place
a rose on my heart, while I'm dying.

It's not the hurt that hurts us more.
It's that feeling- "none cares" hurts us more.
Surely, we can't stop our pain
but certainly, we can heal each other's pain!

Fear Of Love

What is more painful
than the fear of pain itself?

We sob, we cry, complaining-
love hurts, love betrays, love dies;
yet, tell me- what is more painful
than not knowing ever, the ecstasy of love?
What is more painful than not loving ever
for fear of being hurt by your lover?
What is more painful than loving someone
yet, not telling her that you indeed love her?
What is more painful than feeling unloved
when you are indeed, loved by your beloved?
What is more painful than feeling alone
when you could be in embrace of your beloved?
What is more painful than dreaming the moon
yet, never ever kissing that moon in the night?

It's never the love that hurts us more
it's never the pain that pains us more.
It's always our self-fed imaginary fear-
that hurts us, pains us and kills us more.
And this is because- we let fear do so.

Crusade

While bad boys kill millions
good boys must envy them.
If dumb folks can kill so many
clever boys must beat them!

So, good boys write a book-
"Justice- The Good of Killing".
They campaign, they lobby-
pleading to God, endorse killing.

Guess what! God endorses-
He is so sleepy and drunk!
He must have some fun, real fun
He is so sick of usual prank!

So the crusade begins-
Bad vs. Good, Evil vs. Saint.
Children starve, women die
river of blood breaks all bent.

God is deluded, smell of blood
takes Him to a dreamland-
He dreams- saints and saviours
praise Him in wonderland.

Departed Spring

Like the cry of a sad flute
my soul cries- for your whisper.
Like the ache of a thirsty earth
my heart aches- for your laughter.

Winter swallows my love-
chill of your cold stare freezes my heart;
those songs and dances are buried
would bygone spring return and save my heart?

Painting: Amit Bhar

Sweet and Sour

You threw me a rose
and it pierced my heart.
With every dance of my heart-
thorn reminded me sorrow of life.
With every song of my heart-
nectar reminded me joy of life.

My soul composed a song
mixing joy and sorrow together;
then he added fragrance of rose
making this song "essence of life".

You ask me-why love hurts?
Tell me- why rose has thorns
and why moon has shades?
Tell me- why can't we paint black
on canvas of night's darkness?

I like my life to be sweet and sour.
I like my love to be sweet and sour.
Don't even bother kissing me-
if you are just sweet but not bit sour.

When Rose Kills Herself

Then the sun sets-
never to rise again.
You- see dark
think dark, dream dark;
as if, darkness is-
the only truth of your life.
You still try;
try hard- to live
to cheer, to dream.
But- darkness echoes
within wall of the hell.

You cry for-
little help, little support
little love, little comfort-
"hello, could you hear-
what I'm NOT saying?
My soul is dead
it can't sing the song
it should!"

Your cry get lost
in noise of a busy life.
Pain pains you;
yet, it doesn't hurt you
that worse.
But that deaf-ear of-
your loved one, friends
make your soul cry.
You feel- life is cruel
life is bloody worthless.

And then, for first
and the only time-
you slip into hell.

SECTION IV

Light and Inspiration

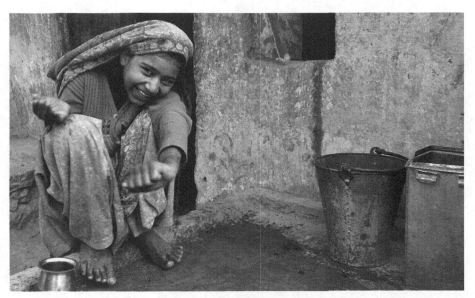

Photo: Akash Gosh

Prayer

O God-
Let me- not just seek love
but seek a heart to spread love.
Let me- not pursue joy
but pursue gratitude to seed joy.
Let me- not ask forgiveness
but ask a soul to show forgiveness.
Let me- not chase glory
but chase wisdom to ignore glory.
Let me- not ask freedom from pain
but ask a heart that embraces all pain.
Let me- not pray for peace
but pray for a mind to cultivate peace.
Let me not treat separately- life or death
but treat both life or death, with equal breath.
Let me fall, stumble and suffer in walk of life
but give me strength and courage to conquer them in life.

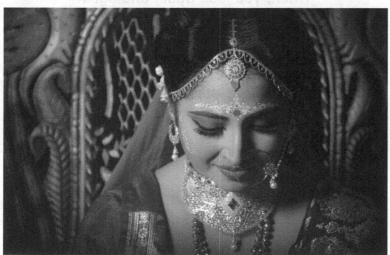

Photo: Akash Gosh

Growth

Know that you have grown-
When, you can touch the sky
yet, you hold earth onto your breast.
When, you worship truth
yet, you don't dismiss other's truth.
When, you love; and suffer
yet, you don't give up loving.
When, you cry silent
yet, you don't whine or blame others.
When, you struggle to stand
yet, you don't give up walking.
When, you see only darkness
yet, you don't give up dreaming.
When, you hear all despair
yet, you don't quit spreading hope.
When, you face persecution
yet, you don't lose faith in humanity.
When, you lose again and again
yet, you don't stop dreaming victory.
When, everybody gives up
yet, you hang in with your limp hands.
When, each and everything fails
yet, you believe that life is not over yet.

Hope

Aeons ago, there was a man-
who had choice to live this earth
all alone, wealthy and undisturbed;
or- to have many in this world.
The man thought-
"well, alone is not even life or death
let's have many- big crowd, big fun!"
So he created many.
Few loved him, many prank him
most ignored him;
few even- labelled him a terrorist.

Now old, he hides himself;
his children now plots his death.
Shameless, this old man smiles-
stupid smile through broken teeth-
"I forgive these ignorant kids"!

Those few- who love him, call him God;
and call his smile- Hope, the light of life.

Bliss Of Sufferings

I'm my best
when I'm in hell of a darkness.
That is where-
I find my honey and sweetness.

I find my lost song
in night's darkness.
I find my lost dance
in my room's darkness.
I find my lost soul
in life's darkness.

O darkness
be my light forever.

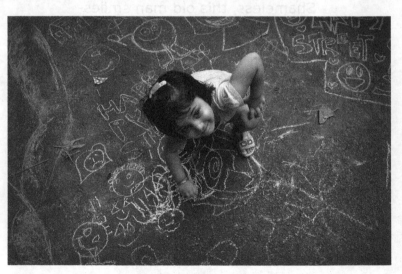

Photo: Akash Gosh

Bubbly Bubbly Bubbles

I would rather like- my life to be a bubble
than a piece of dead, hard stone.
Stone may live an eternity
yet, I can't see rainbow through it.

That's why I like blowing bubbles
those bubbly bubbly bubbles.
I blow them, watch them swell
see rainbow through them
see them floating high in air;
then- I laugh, clap, jump and fall.
And when that bubble pops-
I blow another one.
I don't look back, I just keep blowing;
I blow bubbles with all my fervour
and paint my dream on their shiny surface.

Guess what! My eyes hurt
but I don't care! I'm living in dream.

Conquering Sorrow

If broken-
your soul is fragmented
and your love is crushed.

Don't ask-
who did this to you;
ask-
what is within you!

Make a sea
of your flowing tears;
float your fragmented soul
and then- wait for wind of love
to reunite your fragmented soul!

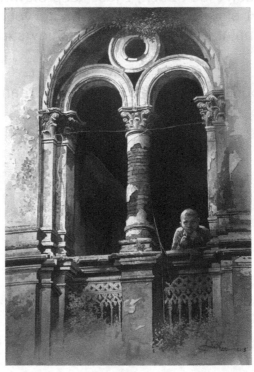

Painting: Amit Bhar

Follow Your Captain

So what-if earth cracks
or sun explodes?
So what- if night hides
or moon implodes?

Ours is a whirling universe-
sun spins, sea swirls
wind spirals, time twirls;
day spins night, night day
hay spins wind, wind hay.

Neither joy nor sorrow
wins over flow of time.
Neither life nor death
wins over passage of time.

Even- time dies;
moment dies, to be reborn
to another moment.

Why the man is fatalist-
why they worry to misery
and act as death's catalyst?

What has to happen
must happen;
so- sing the song well
in tune of your Captain.

I Refuse To Suffer

Cloud says-
oh, mighty Thunder
hit me harder, pain me severe.
I might writhe and explode
yet, I would never ever suffer.

I might shed tears;
yet, I vow-
I would turn my tears
into a mighty river.

Then-
I would heal-
heart of cracked earth.
I would care-
that seed, giving birth.

I pledge-
I would turn pain
into infinite gain.
If pained, I would sing-
song of a a cowboy
If broken, I would dance-
dance of a tomboy.

Oh mighty Thunder-
between me and suffering-
lies power of my choice.
I would choose-
to love, to heal.
to sing, to dance.
Pain might get me down
but I would stand up again;
agony might break my heart
but I would heal myself again.

Life is All About Chasing The Rainbow

Not all rain comes with glitter of rainbow
not all memory comes with sweetness of dream;
but few do- defying abyss of human disappointment.
Life is all about clinging to those rainbows and dreams
and striving to live eternity with dance on broken legs.

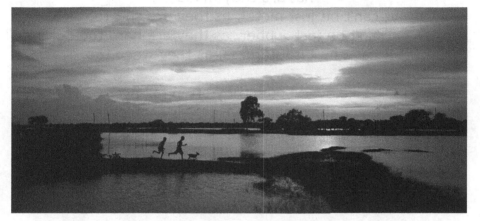

Photo: Akash Gosh

Resilience

Few people are burnt in fire
crumbled in pressure, bent in shear
yet- they rebound again;
they rebound even stronger than ever.

What are they made of?
It can't be just metal, as they are soft too.
It can't be just rubber, as they are hard too.
It can't be just stamina, as they weep too.

Like everybody, they often fall over
break their legs, bruise their shoulders
and even, they often whimper.
While crying, they pull themselves up
wipe off their tears, fist on their chest
and mutter- "come on, you can do it".

Extra ordinaries are so much ordinary!
Yet- they love, when others hate
they hope, when others despair.
It's their soul that glows in darkness.

Resonate

Neither would I die before death
nor would I live- life of a death.
I would dance even on broken leg.

Nothing sleeps, universe vibrates-
atoms, sub-atoms, strings- all.
If my invisible cells don't give up
then why would I? Why?

I would dance the rhythm of –
wind and river- now, and life after.
The rhythm asks me- "resonate"
Yes, by all means, I must resonate.

Shine Through Pain

When-
cloud covers sky
night comes too soon
fear jolts your heart
and you see anything but light-
Then-
you know- it's your time
to shine through darkness.

You might- go pale
go dizzy and gasp air;
sit and relax if you have to,
lie down flat, if you have to
but don't ever faint.
Rub eyes and clear your vision-
you might just see- a faint light;
so faint- that you might even miss it-
unless you are very careful.

Take- few deep breaths;
calm your heart, calm your mind
and follow that light.

You might fall, you might bang head
it might pain, it might even bleed
but don't you give up;
for God's sake- don't give up.
Rest if you have to, cry if you have to
but don't ever give up.

In end-
you aimed for moon
but now- are in Sun.

Colour Of Death Is Rainbow

Colour of death is rainbow
if tinted with hue of love.

Cloud longs to die-
for she knows-
in death, she is a rainbow
In after-life, she is a river.

While thunder roars-
she prepares her death;
she sprays over sunbeam silently
she sprinkles over wind leisurely.
Now in death, she is a rainbow
with seven colours of her love.

Then-
from her tears, she reappear
as a rainbow-hearted river.

The Shadow

Ripple ripples
and shadow shatters;
ripple ripples
and shadow shatters.
Ripple laughs loud -
"shame on you, shadow
I shatter you again
and again"
Shadow smiles-
"praise on me
I shatter, yet I re-form
I sing song of life".

Then- sun shines
and ripple dies;
but humble shadow
smiles, even bigger.

Photo: Akash Gosh

This Too Shall Pass

Are you crying? Cry-
cry as much as, you have to
close the door if you have to.
Make a sea of your tears
and wash your sorrow and anger!

Do you feel lighter now?
Feel like-
that heaviness in heart, little lighter
that breathing of yours, little easier!
You are sobbing now-
no hurry, keep sobbing.

Why those bad things happen to you-
when you have so much on your plate?
You feel like – you are singled out
you feel like- you are such a misery!
Don't you?

You are hurt, you are torn
you feel like- you're dying!
Let me tell you- you did well;
you cried, when you had to
you took time, when you needed to.

Have you ever seen-
when cloud covers the sky?
Pained and grieved, sky hides her face,
then- sky cries and cloud goes off.
Believe me-your this pain too
soon be over!

Just wait please, little more
a little. This too shall pass.

Why Can't You Be Happy Again

Happiness is never a piece of cake
that you can buy safely
in store of your adulterated culture.
It's your conscious choice to look within
while others entice you to look outside.

Be yourself, be who you are-
you are that little child, who once caught fire
even without a trace of fear;
you are that little child, who jumped into river
without learning swimming ever;
you are that little child, who once saw the sky
and winged his shoulders to fly;
you are that little child, who once saw a flower
then exploded in joy and laughter.

Tell me-
why that lion in you, is dead now
why that beautiful soul is dead now?
Tell me-
why can't you be happy again?

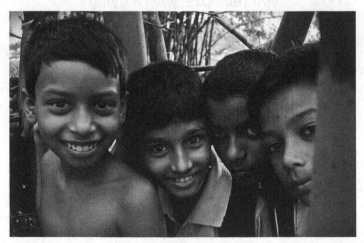

Photo: Akash Gosh

We Are All Born Poet

I don't know –
what a good poem is
or, if poet only writes a poem!

But I know
there are certain songs
within our heart-
which are so true, alive
and close to our heart;
they just flow of their own.

That's why-
I hear poem- in cry of a child
in whisper of a lover
and in laughter of a river.

Believe it or not-
we all are born poets.
We have hearts to listen to a song
we have souls to compose that song.
Yet- poetry dies unborn, within us.
For- we crush our hearts
with dull chores of life.
We starve our souls
oblivious, soul too has a thirst.

Then- a day comes, when-
we have beautiful music
and glittering stage
but- we have no song left in us.

Every Moment Counts

Every moment counts-
for life is too short;
as short as blink of an eye.
If- you sleep too long
hate too long, fight too long
It will be over, over-
even before you know.

Regret is destruction
disappointment is distraction
hatred is degeneration
anger is disintegration;
In sea of such darkness-
love is the only light
you need to hang on to.

Life is a sea of tragedy.
So- you need a boat to sail
through this cruel, whimsical sea.
Love is that only boat-
it might sway
it might even sink.
Yet- do you really have a choice
but not to embark on a boat
while sailing this rough sea?

Fall in sleep, loving
and wake up at morning, loving.
Say "no" with a grace
and "yes" with a kindness.
Smile through tears
and laugh through fear.
Embrace whomever or whatever
as rejection never takes you anywhere.

If you have to live this tragic life
then- why don't you
do it with a smile?

Feel like crying?
Cry.
Feel like laughing?
Laugh.
Feel like dancing?
Dance.
But for God's sake
never ever hold your soul back.
Every moment counts-
for life is too short;
as short as blink of an eye.

The Messiah

When- sun stops shining
moon stops smiling
and wind stops singing;
then you know-
it's time to play moan of a sad violin.
Strings would writhe in pain
air would ache in agony
heart would twist in torment
tears would wet this earth;
and utterly exhausted-
you would fall to sleep.
Then next day, in dawn
you would wake up-
with song of cuckoos.

But that night is not easy!

You are left alone
in corner of a room.
Or maybe- you're
in noise of a celebration;
yet- you're very alone.

The ground you stand on-
moves away from you.
Your heart feels heavy
eyes shine with tears-
few drops roll over your cheeks.
You wonder- what went wrong? How?
Yet- you could not figure it out.
Your mind wants to pass the blame
but your soul holds you back.

You may even pray-
O God-
give me strength, give me patience
give me kindness, give me forgiveness.
You wipe your tears- and fist your chest
saying- I' ll hang on, I won't give up,
I can do it.

You do this drill
once- twice- few times
maybe- many many times.
Are you trying to smile through pain?
Are you trying to do what God would not have dared?
Yes, you are.
Bravo! You're the champion! God needs you.
We need you. This dying world needs you.

This world is full of dust and smoke
this world is full of dark and dungeon
this world is full of lie and betrayal.
Yet- you're there, a mortal being (not even a God)-
who does not whine, who does not blame
who does not curse, who does not condemn.
You just shed tears alone, and fist your chest
saying- I won't give up. I will hang on.
You know-
I have a title for you- The Light!
I have a name for you- The Messiah!

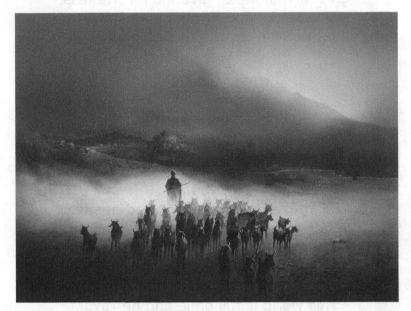

Painting: Amit Bhar

End